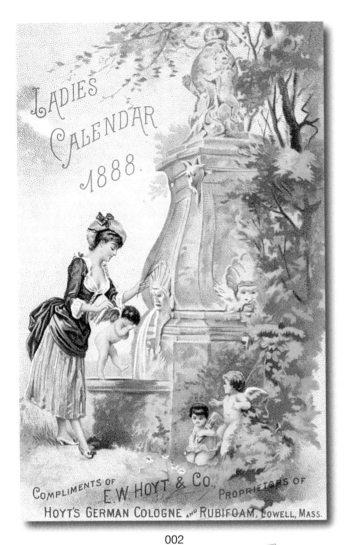

002

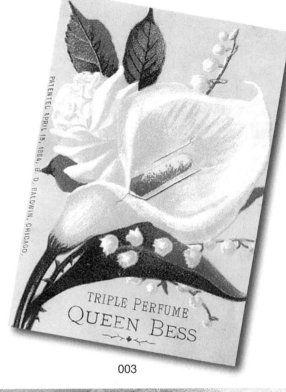

003

004

005

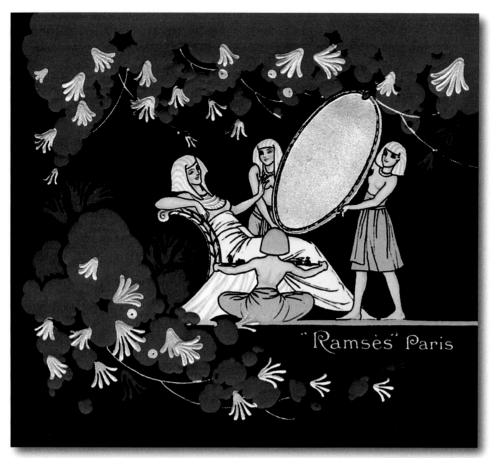

"Ramsès" Paris

006

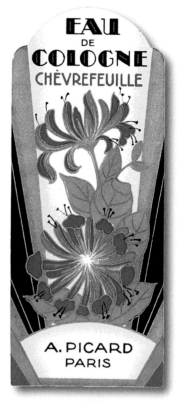

EAU
DE
COLOGNE
CHÈVREFEUILLE

A. PICARD
PARIS

007

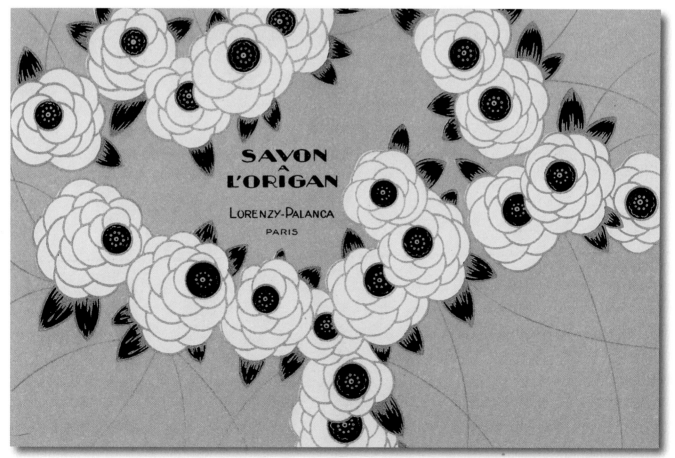

SAVON
À
L'ORIGAN

LORENZY-PALANCA
PARIS

008

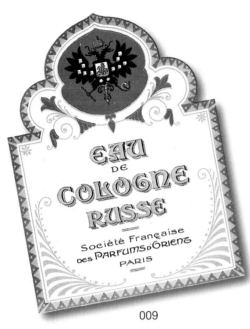

009

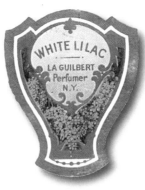

010

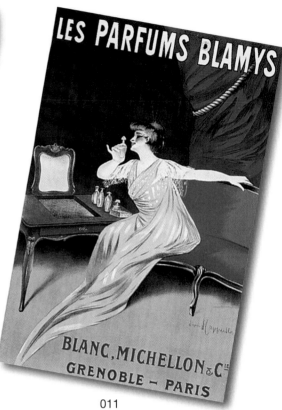

011

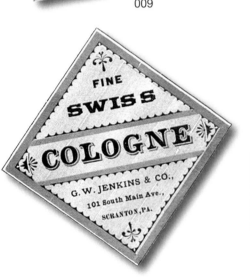

012

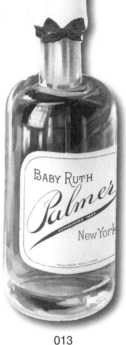

013

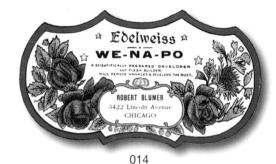

014

015

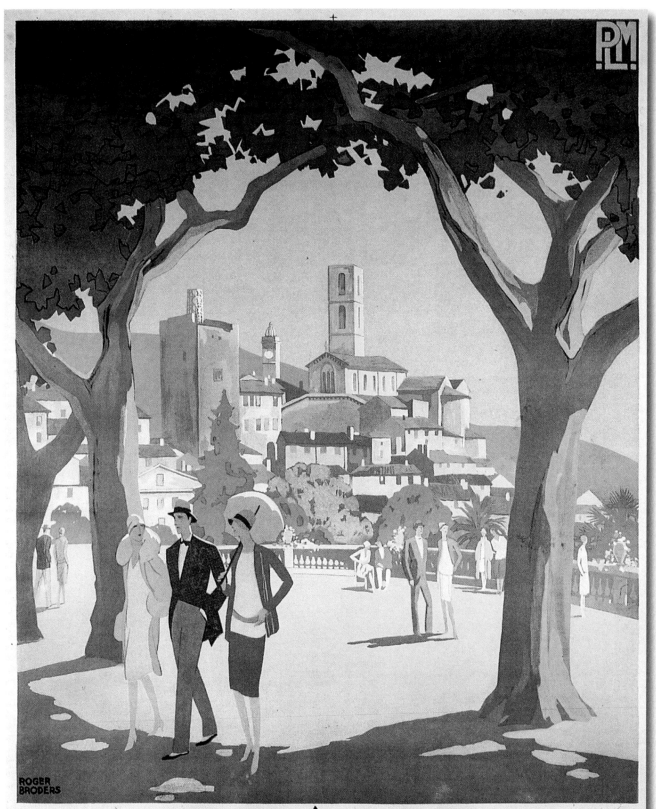

ROGER
BRODERS

GRASSE
STATION CLIMATIQUE

LA VILLE DES FLEURS ET DES PARFUMS

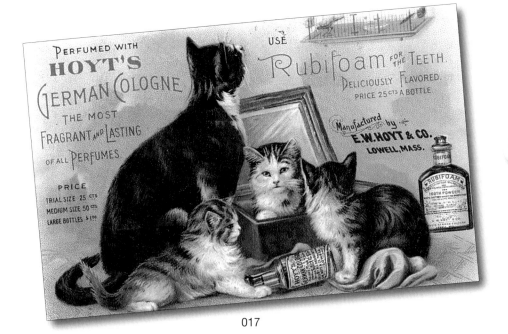

017

018

019

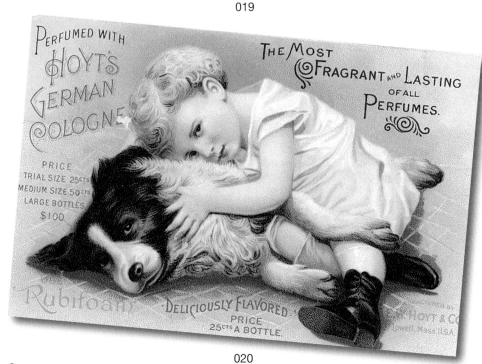

020

021

QUEEN BEAUTY

022

BACORN'S
Lilac
WITCH HAZEL
4 Fld. Ounces

Makers of Skin-Glo Creme
THE BACORN CO.
Perfumers
ELMIRA, N. Y.

023

QUEEN BEAUTY

024

N'ARD
—
THE STANDARD
PERFUMES CO.
NEW-YORK, U.S.A.

025

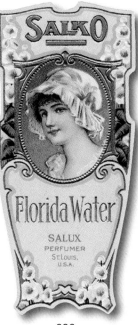

SALKO

Florida Water

SALUX
PERFUMER
St.Louis,
U.S.A.

026

Lady Marian
TOILET WATER

Salux
Perfumer
St.Louis,
U.S.A.

027

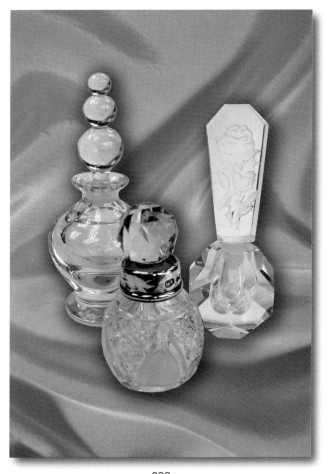

028

HELIOTROPE
THE STANDARD
PERFUMES CO.
NEW-YORK U.S.A.

029

7

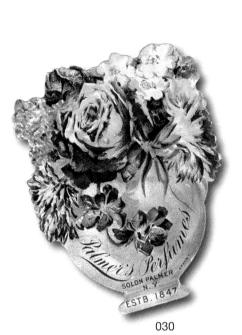

030

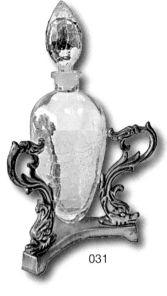

031

032

033

034

FLORAL BOOKMARK

CASHMERE BOUQUET
Perfume

035

036

037

038

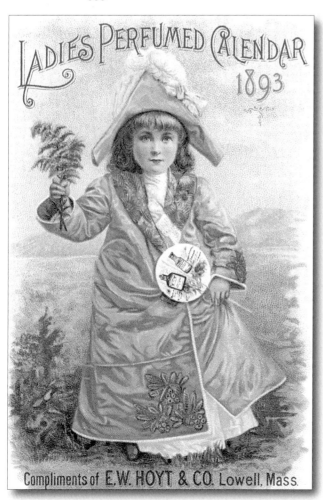

039

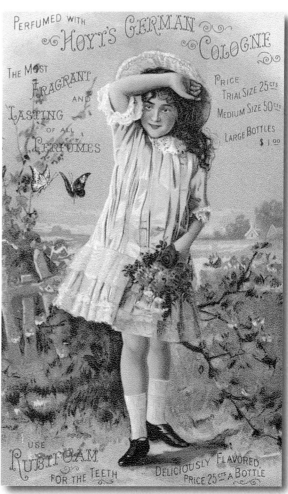

040

9

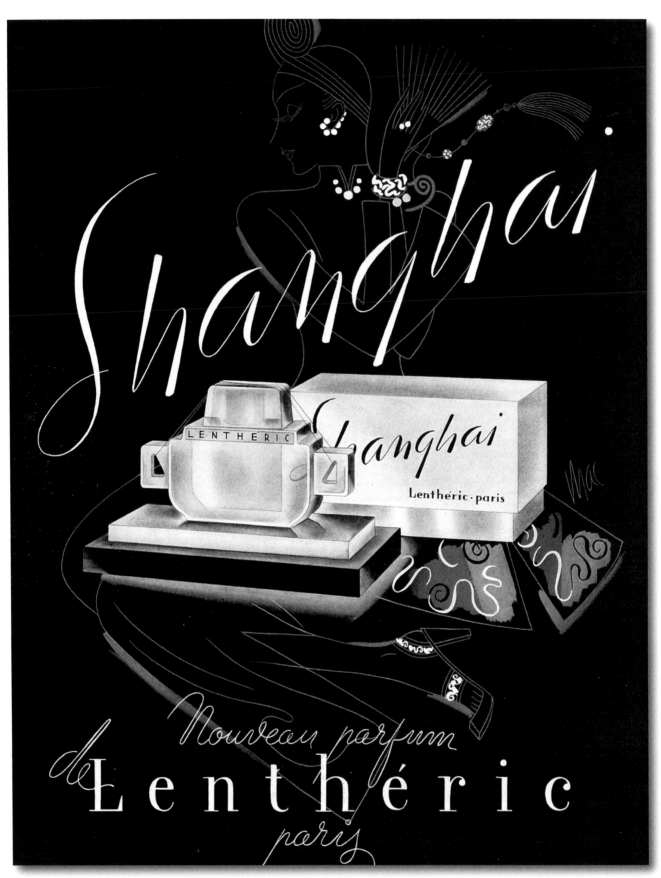

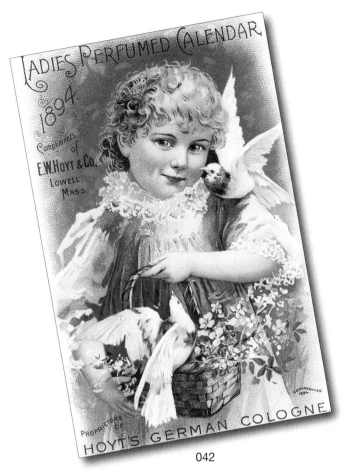

042

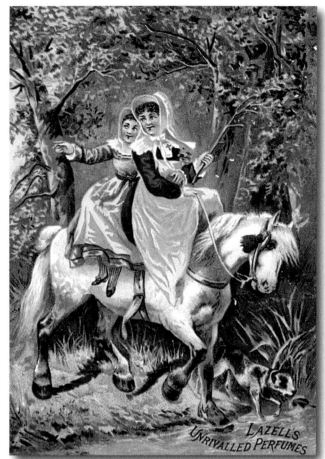

043

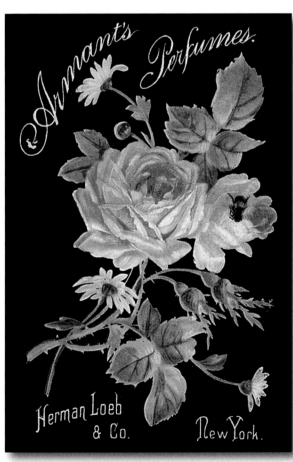

044

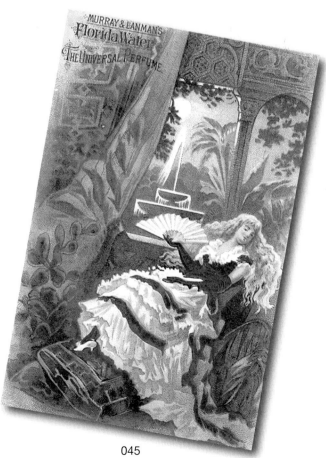

045

046

047

048

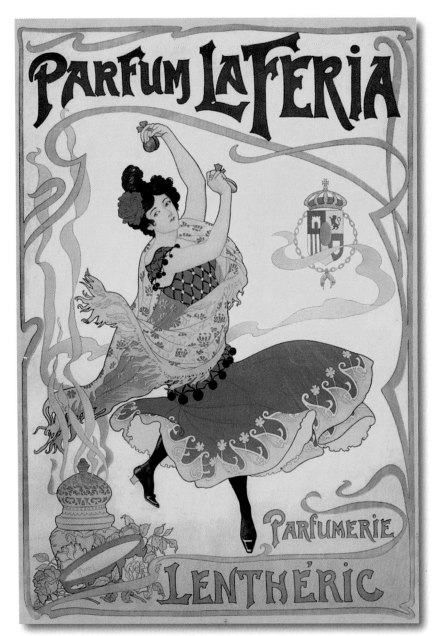

050

049

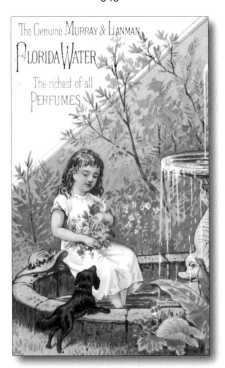

051

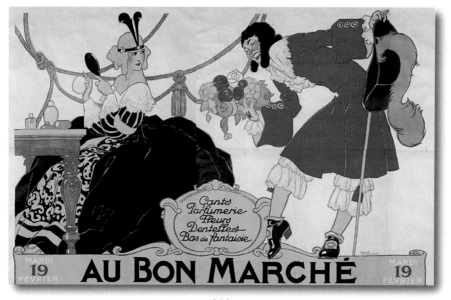

052

053

054

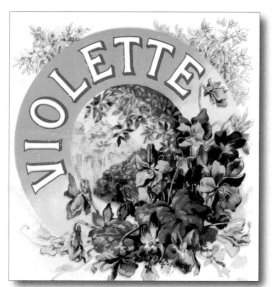

055

057

058

056

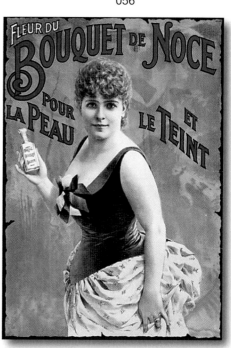

059

13

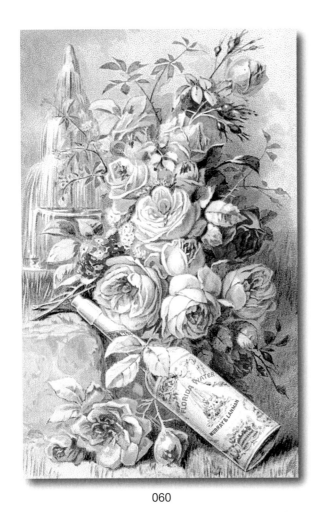

060

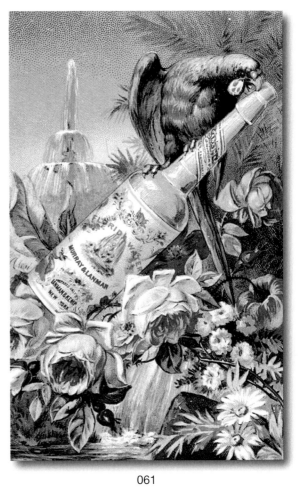

061

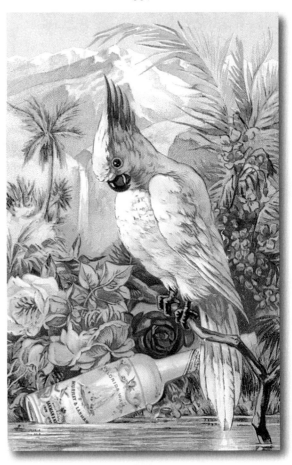

062

063

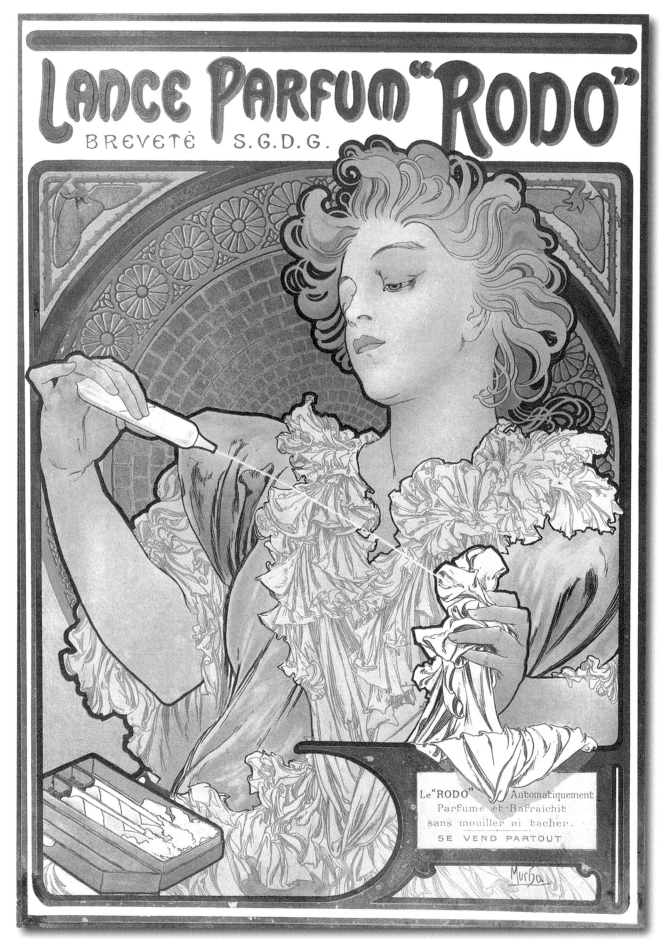

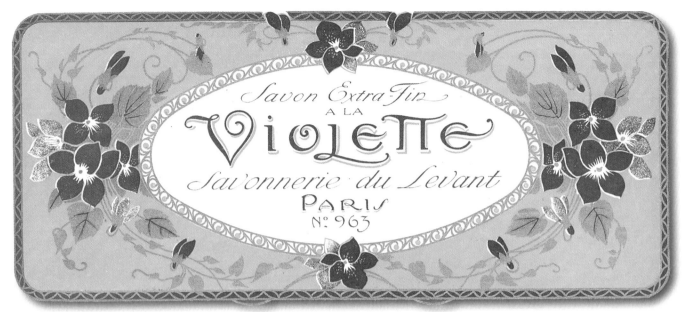

Savon Extra-Fin
A LA
Violette
Savonnerie du Levant
PARIS
N.º 963

065

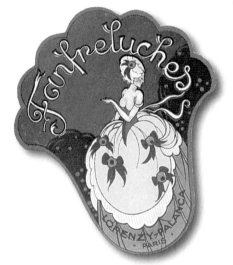

066

EAU
DE
COLOGNE

067

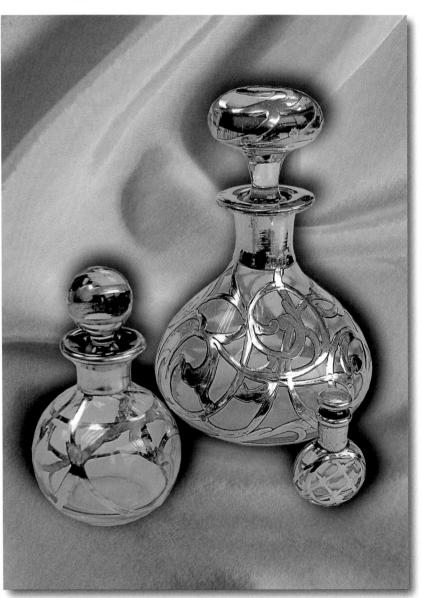

068

069

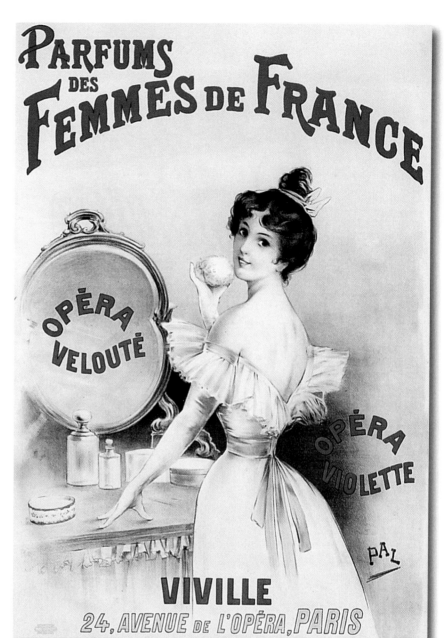

070

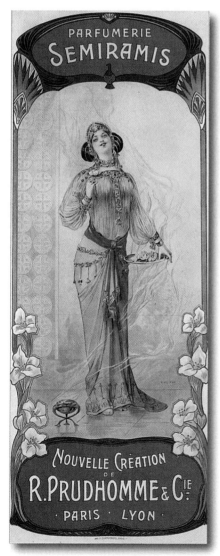

071

072

073

17

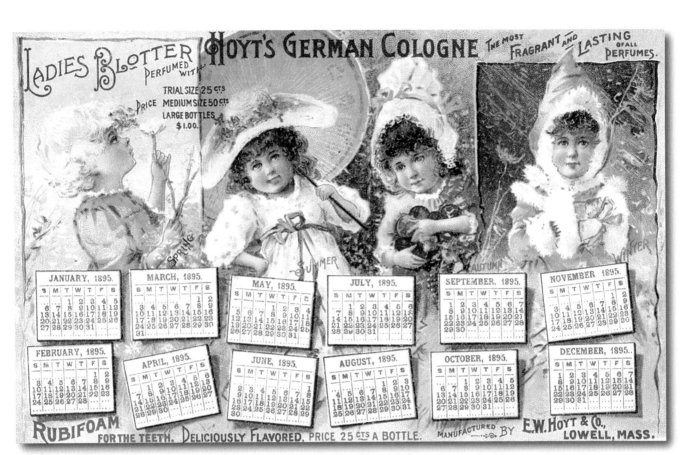

074

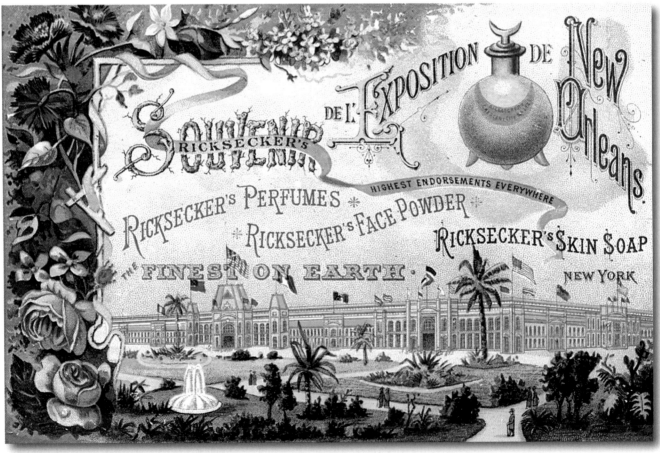

075

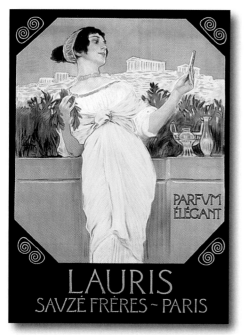

PARFVM
ÉLÉGANT

LAURIS
SAVZÉ FRÈRES ~ PARIS

076

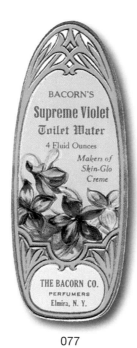

BACORN'S
Supreme Violet
Toilet Water
4 Fluid Ounces
Makers of
Skin-Glo
Creme

THE BACORN CO.
PERFUMERS
Elmira, N. Y.

077

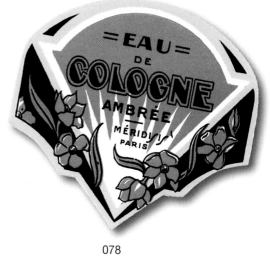

=EAU=
DE
COLOGNE
AMBRÉE
MÉRIDI
PARIS

078

WHITE ROSE
LA GUILBERT
Perfumer
N.Y.

079

CARNATION
PINK
C.M. RICH
PERFUMER
N.Y.

080

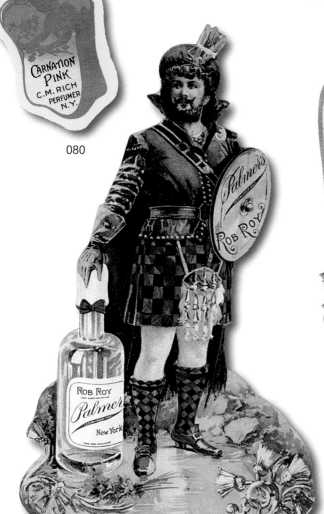

Palmers
ROB ROY

ROB ROY
Palmer
New York

083

BACORN'S
CRAB APPLE
TOILET WATER
4 Fluid Ounces
Makers of Skin-Glo Creme

THE BACORN CO.
PERFUMERS
Elmira, N. Y.

082

081

084

SAN REMO

Toilet
Water
A
DELIGHTFUL
TOILET REQUISITE

Dr. J.B. Lynas & Son,
Perfumers.
LOGANSPORT,
IN D.

085

086

087

088

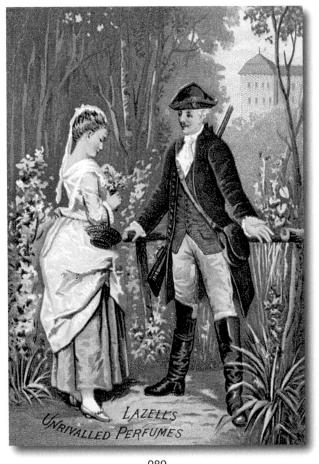

089

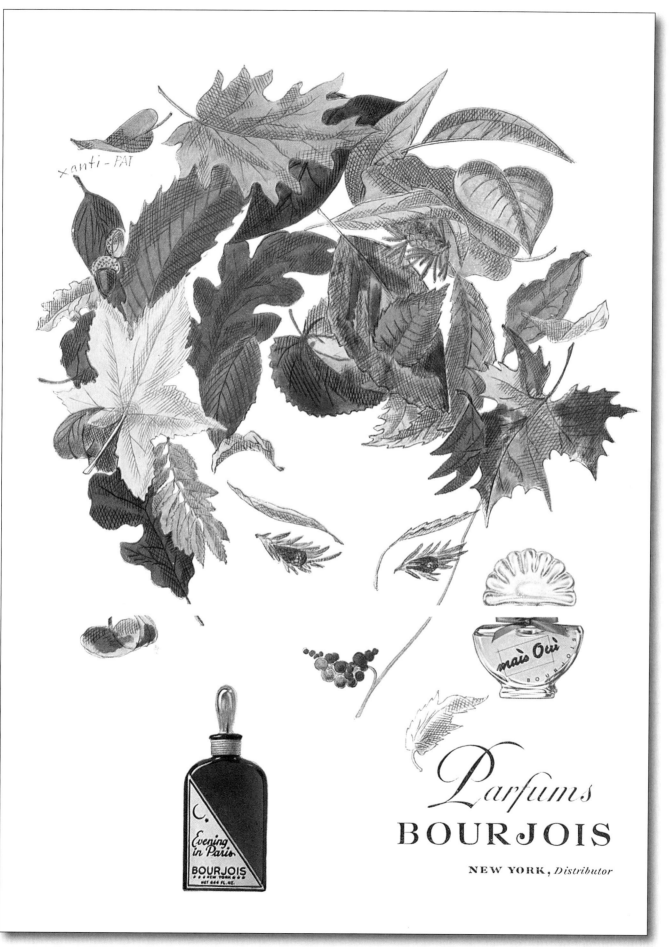

091

092

093

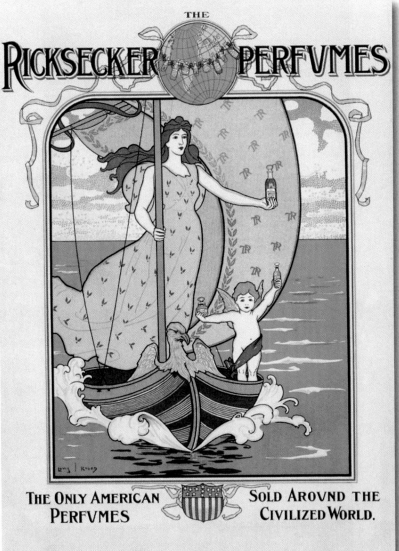

094

095

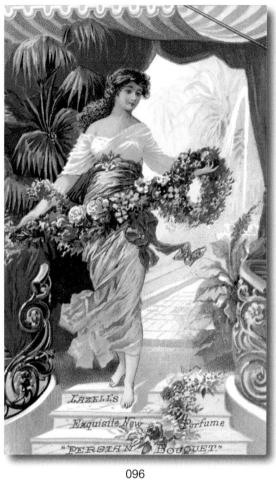

096

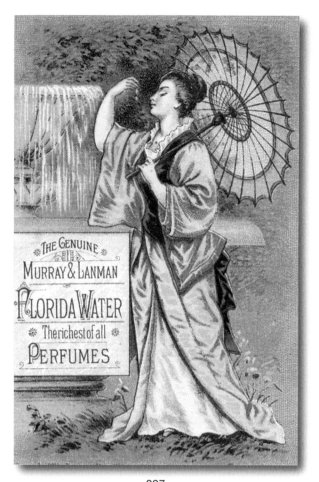

097

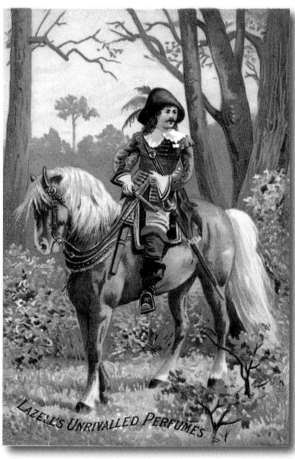

098

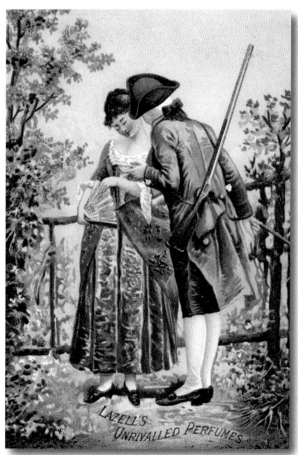

099

23

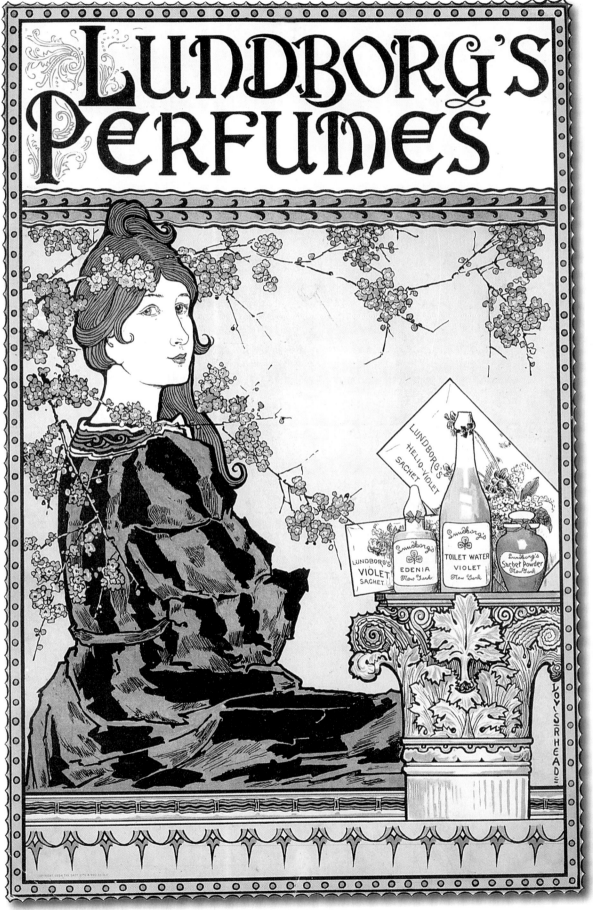

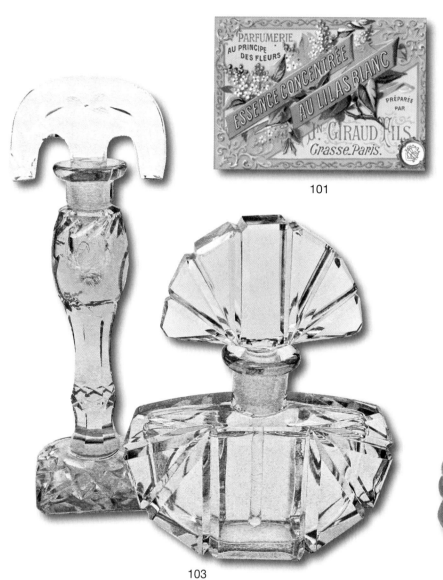

101

102

104

103

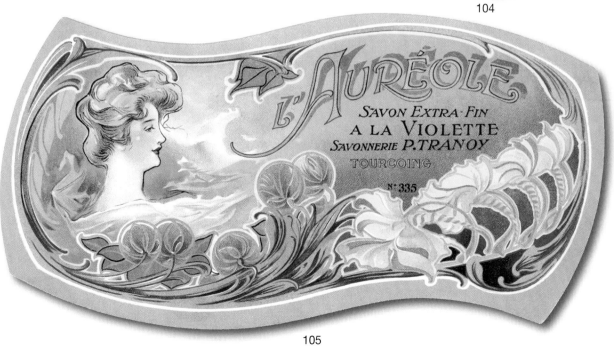

105

106

107

108

109

110

111

112

113

114

115

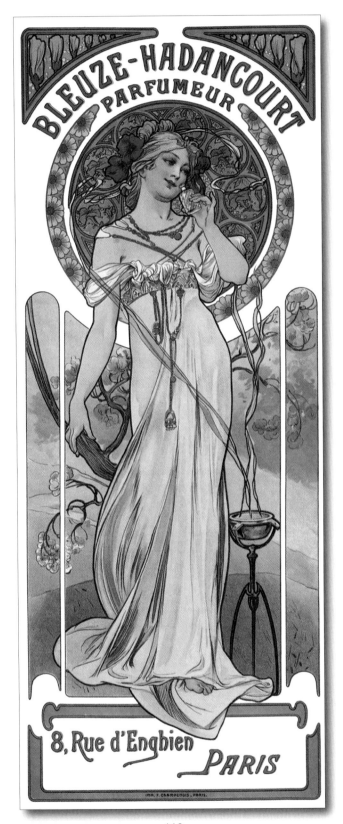

116

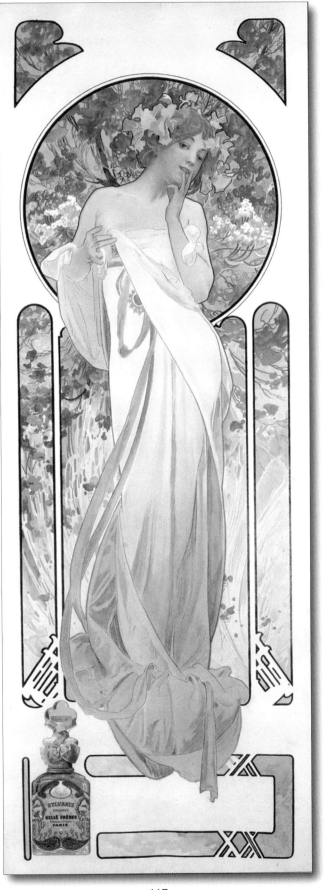

117

28

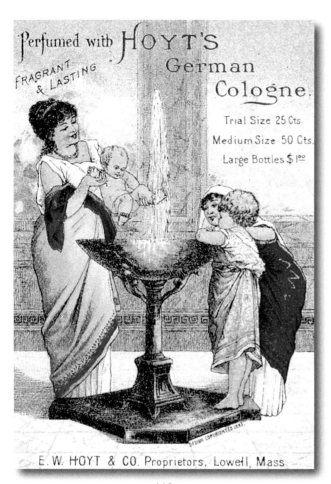

118

119

120

121

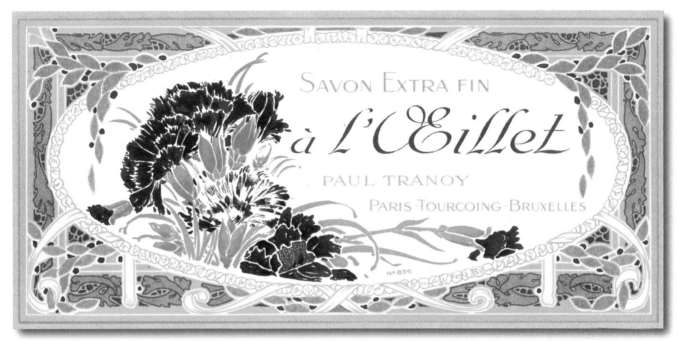

122

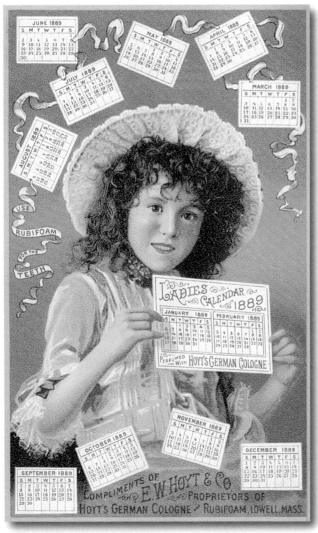

123

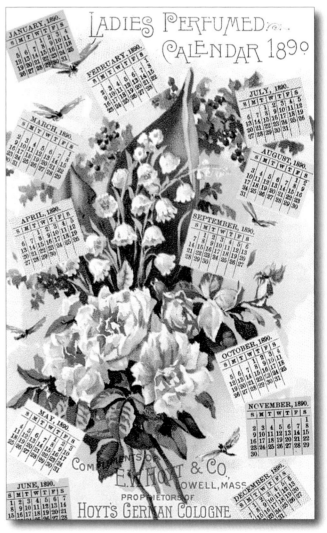

124

125

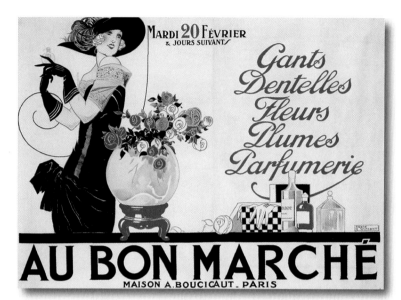

126

127

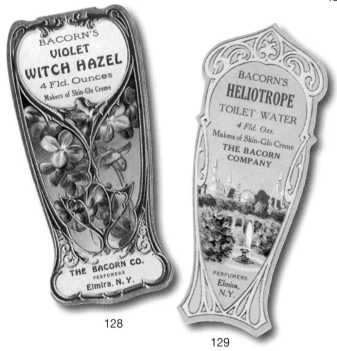

128

129

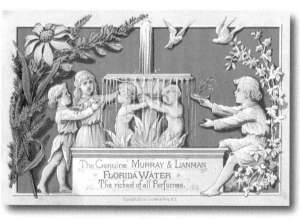

130

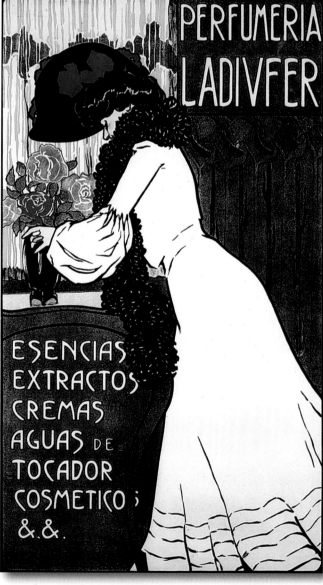

131

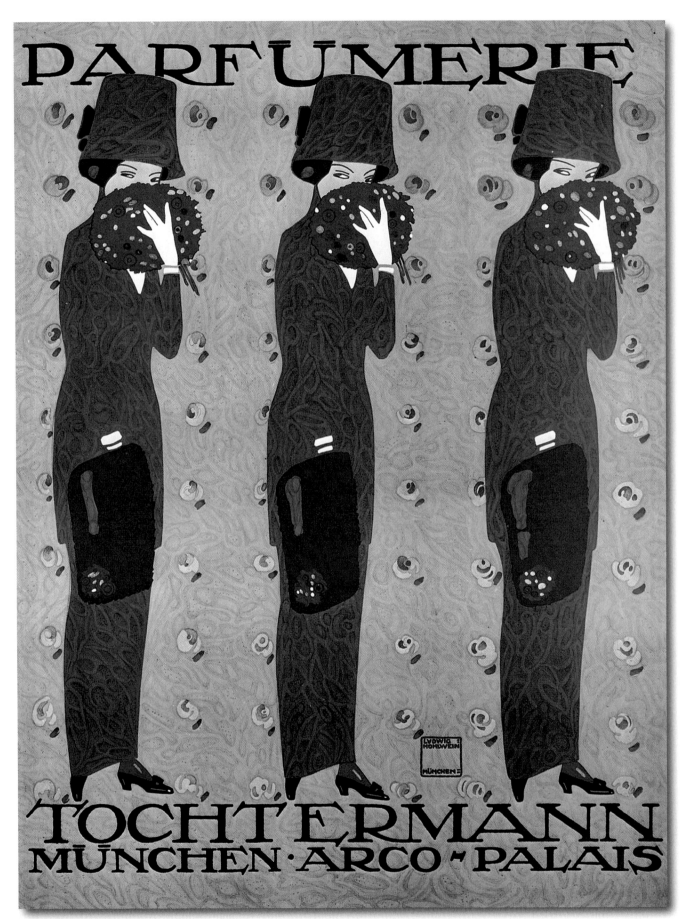

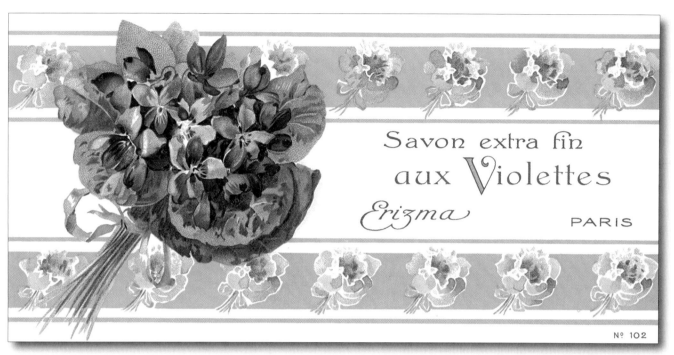

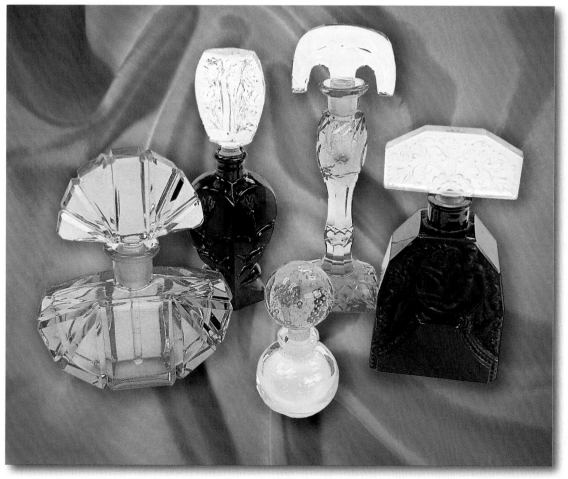

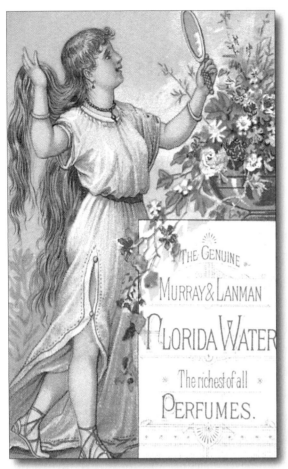

135

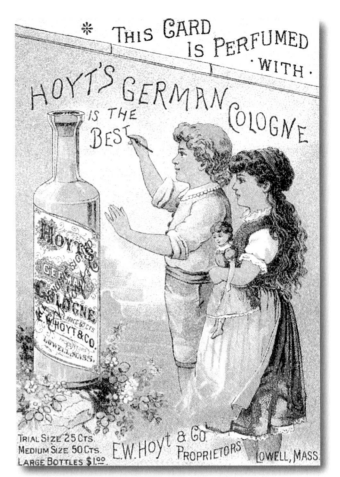

136

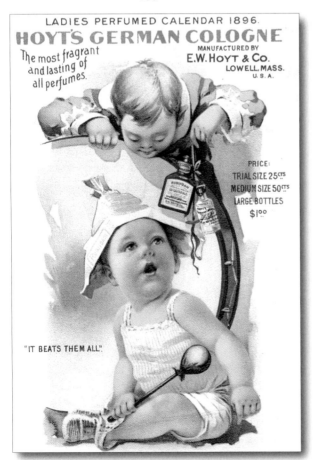

137

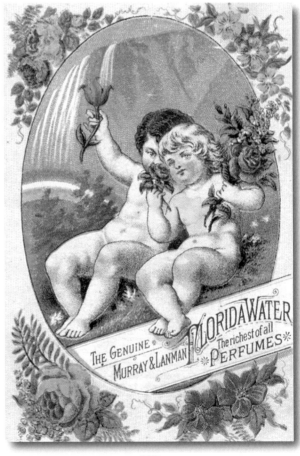

138

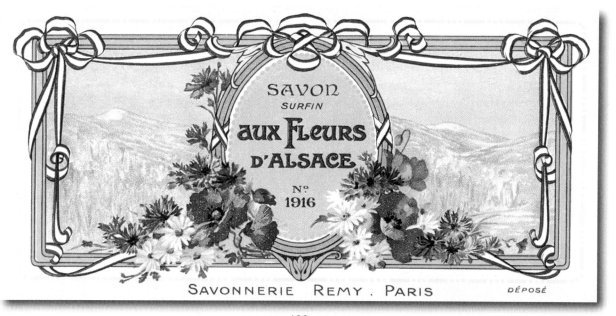

139

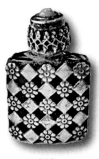

140

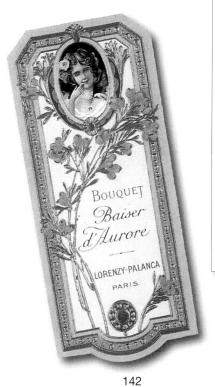

142

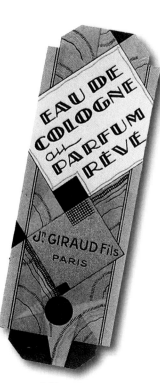

141

144

143

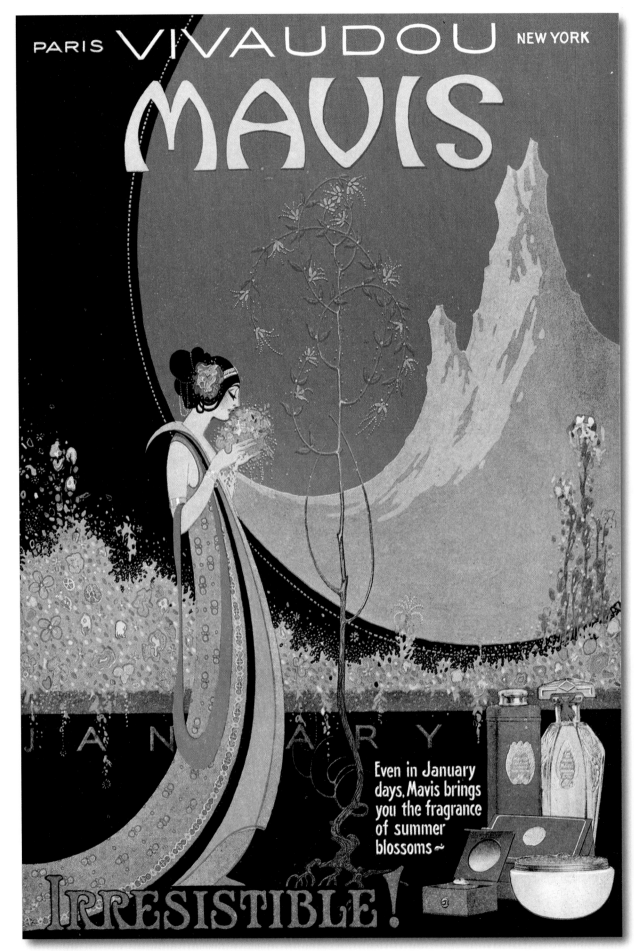

146

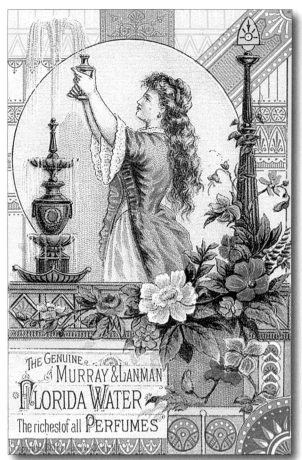

147

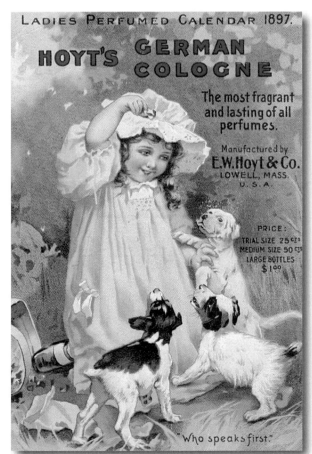

148

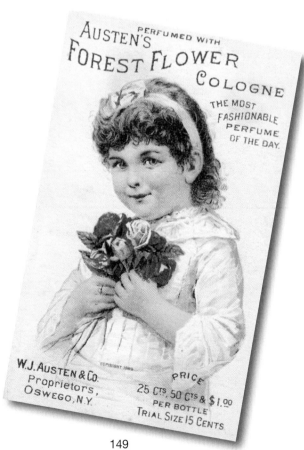

149

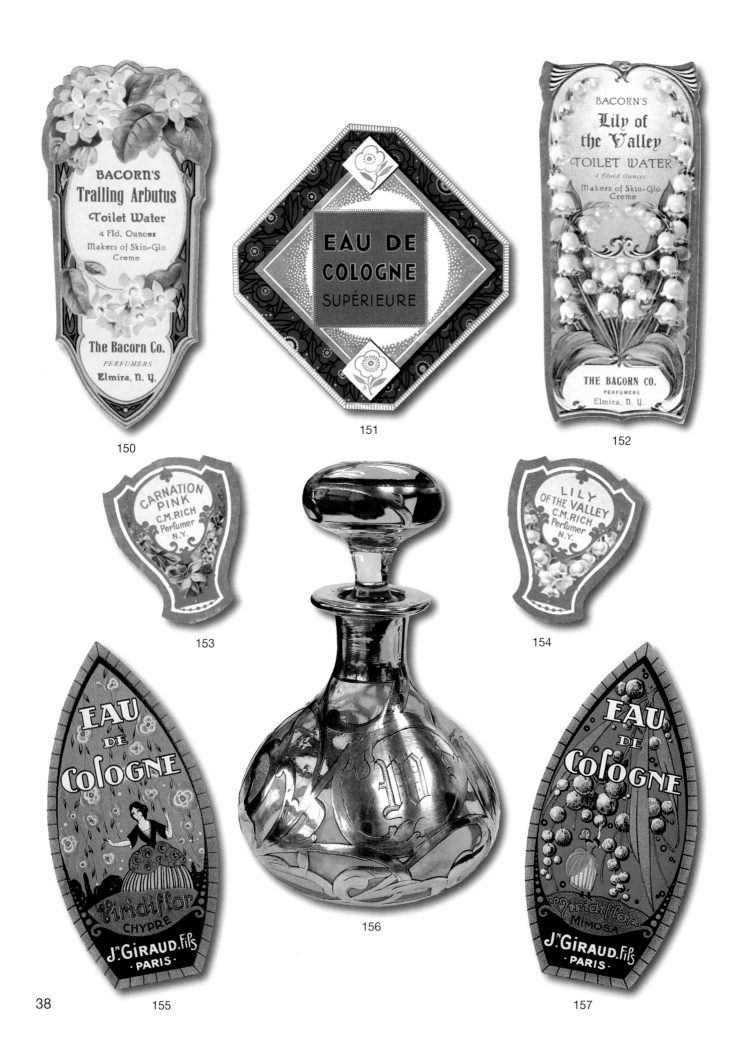

BACORN'S
Trailing Arbutus
Toilet Water
4 Fld. Ounces
Makers of Skin-Glo
Creme

The Bacorn Co.
PERFUMERS
Elmira, N. Y.

150

EAU DE
COLOGNE
SUPÉRIEURE

151

BACORN'S
Lily of
the Valley
TOILET WATER
4 Fluid Ounces
Makers of Skin-Glo
Creme

THE BACORN CO.
PERFUMERS
Elmira, N. Y.

152

CARNATION
PINK
C.M.RICH
Perfumer
N.Y.

153

LILY
OF THE VALLEY
C.M.RICH
Perfumer
N.Y.

154

EAU
DE
Cologne
Viridiflor
CHYPRE
Jⁿ Giraud. Fils
· PARIS ·

155

156

EAU
DE
Cologne
Viridiflor
MIMOSA
Jⁿ Giraud. Fils
· PARIS ·

157

38

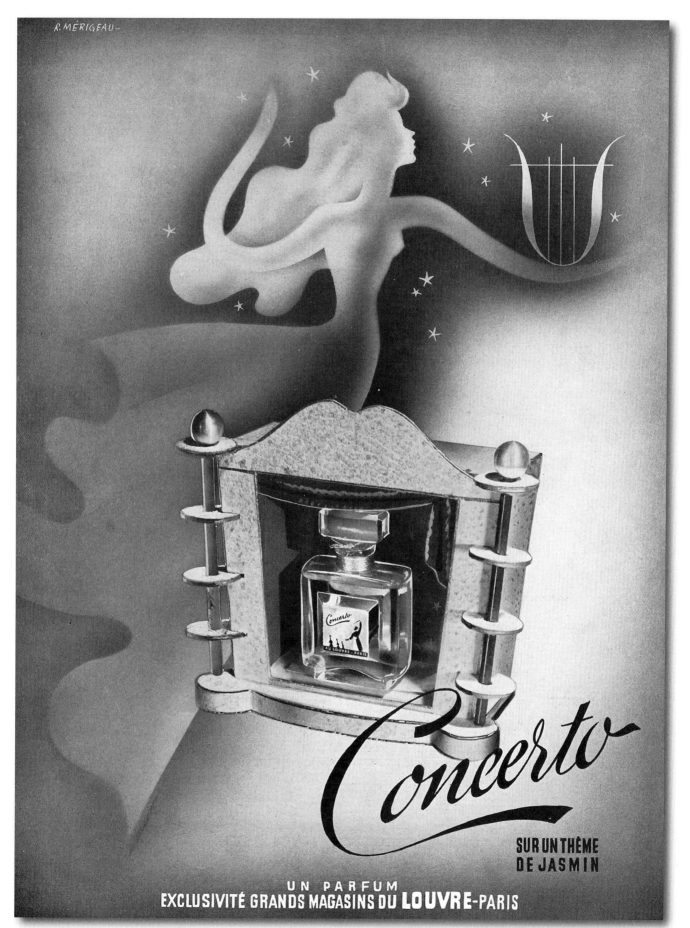

Concerto

SUR UN THÈME
DE JASMIN

UN PARFUM
EXCLUSIVITÉ GRANDS MAGASINS DU **LOUVRE**-PARIS

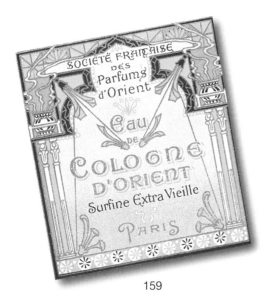

159

160

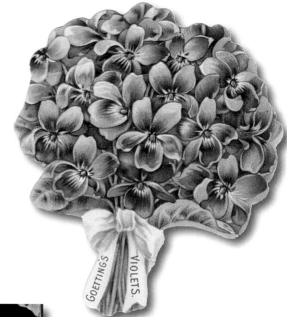

161

162

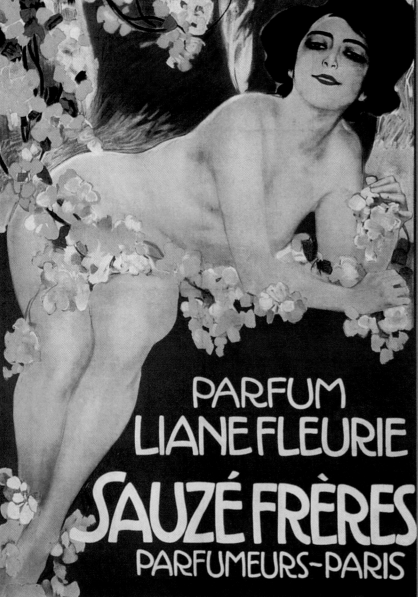

163

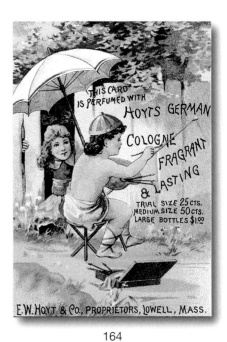

164

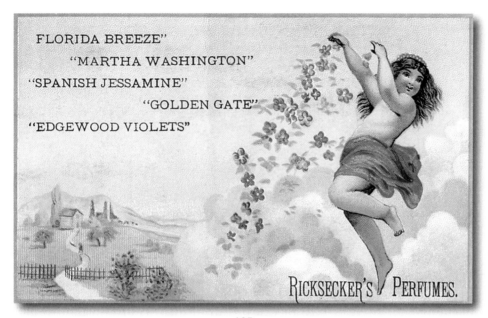

FLORIDA BREEZE"

"MARTHA WASHINGTON"

"SPANISH JESSAMINE"

"GOLDEN GATE"

"EDGEWOOD VIOLETS"

RICKSECKER'S PERFUMES.

165

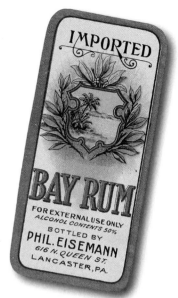

IMPORTED

BAY RUM

FOR EXTERNAL USE ONLY
ALCOHOL CONTENTS 50%
BOTTLED BY
PHIL. EISEMANN
616 N. QUEEN ST.
LANCASTER, PA.

166

EAU DE COLOGNE
AUX FLEURS
AU CAPITOLE - TOULOUSE

167

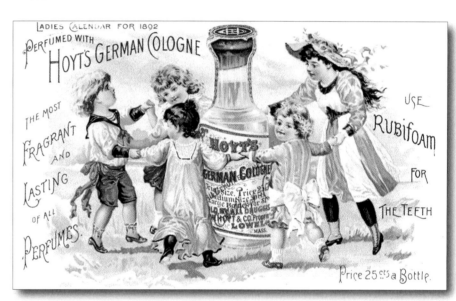

LADIES CALENDAR FOR 1892

PERFUMED WITH

HOYT'S GERMAN COLOGNE

THE MOST

FRAGRANT

AND

LASTING

OF ALL

PERFUMES.

USE

RUBIFOAM

FOR

THE TEETH

Price 25 cts a Bottle.

168

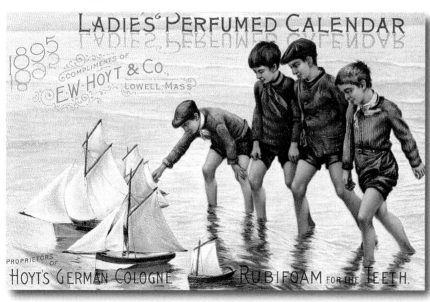

LADIES' PERFUMED CALENDAR

1895

COMPLIMENTS OF

E.W. HOYT & CO.,
LOWELL, MASS.

PROPRIETORS OF

HOYT'S GERMAN COLOGNE RUBIFOAM FOR THE TEETH.

169

Standard
BAY RUM
Contains 37% Grain Alcohol.

GUARANTEED BY Phil Eisemann UNDER FOOD &
DRUG ACT, JUNE 30, 1906, SERIAL NO.
34078

Prepared by
PHIL EISEMANN
LANCASTER, PA.

170

41

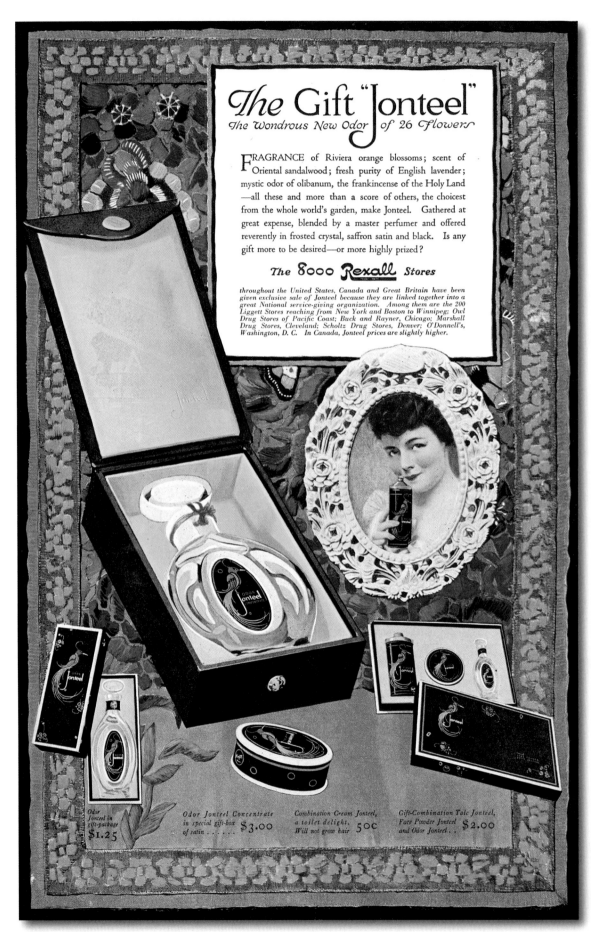

172

173

174

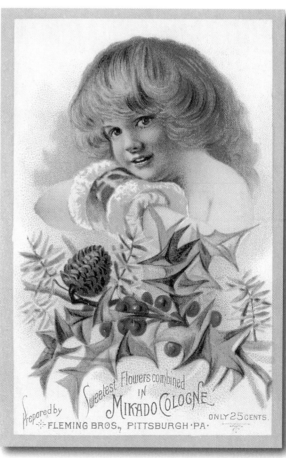

175

43

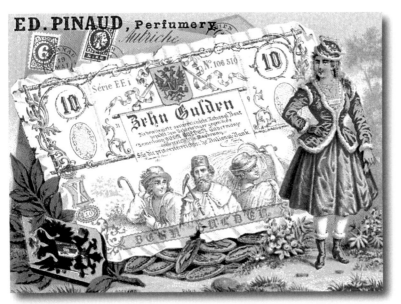

176

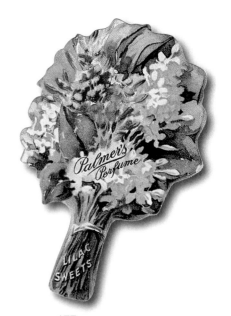

177

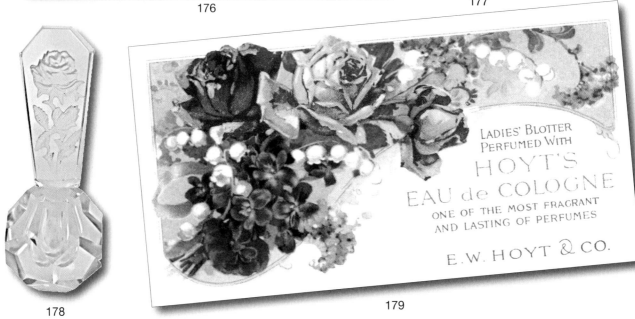

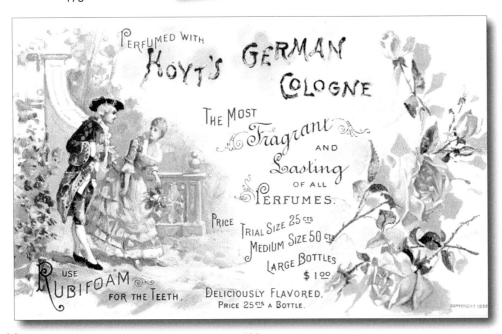

178

179

180

181

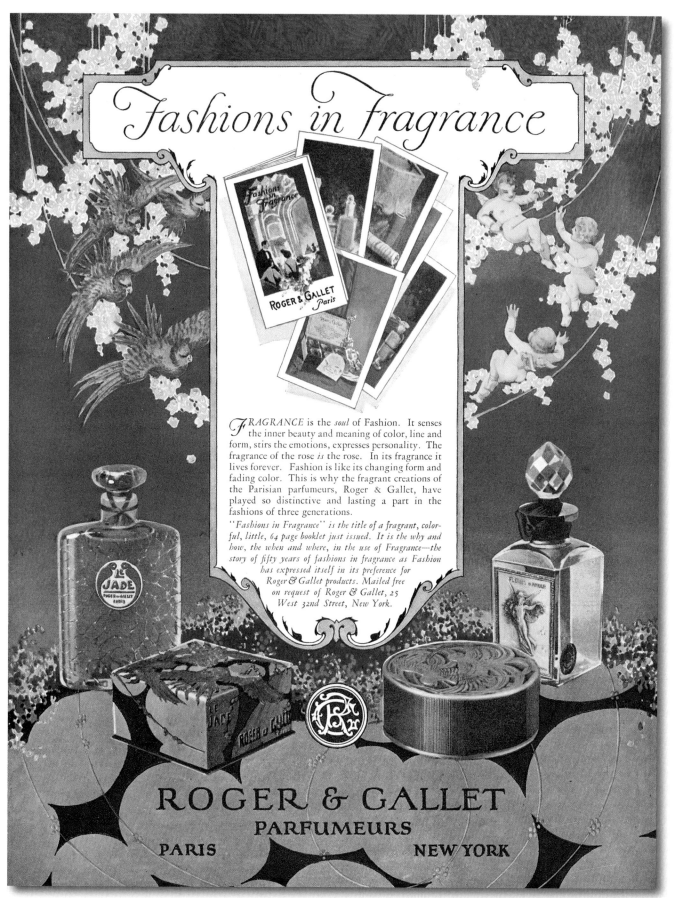

Fashions in Fragrance

*F*RAGRANCE is the *soul* of Fashion. It senses the inner beauty and meaning of color, line and form, stirs the emotions, expresses personality. The fragrance of the rose *is* the rose. In its fragrance it lives forever. Fashion is like its changing form and fading color. This is why the fragrant creations of the Parisian parfumeurs, Roger & Gallet, have played so distinctive and lasting a part in the fashions of three generations.

"Fashions in Fragrance" is the title of a fragrant, colorful, little, 64 page booklet just issued. It is the why and how, the when and where, in the use of Fragrance—the story of fifty years of fashions in fragrance as Fashion has expressed itself in its preference for Roger & Gallet products. Mailed free on request of Roger & Gallet, 25 West 32nd Street, New York.

ROGER & GALLET
PARFUMEURS
PARIS NEW YORK

Our Own
LITTLE
FAIRY'S
BATH
PERFUME

LINCOLN CHEMICAL WORKS
CHICAGO, ILL.

183

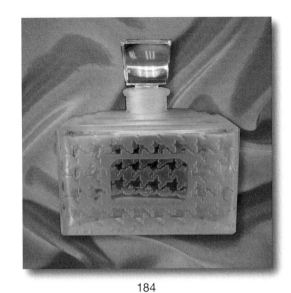

184

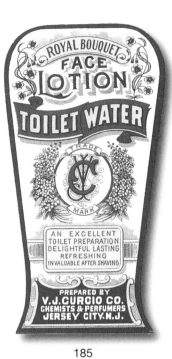

ROYAL BOUQUET
FACE
LOTION
TOILET WATER

TRADE
MARK

AN EXCELLENT
TOILET PREPARATION
DELIGHTFUL LASTING
REFRESHING
INVALUABLE AFTER SHAVING

PREPARED BY
V. J. CURCIO CO.
CHEMISTS & PERFUMERS
JERSEY CITY, N.J.

185

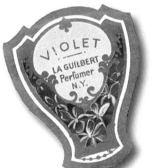

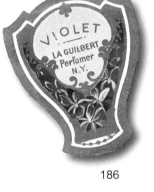

VIOLET
LA GUILBERT
Perfumer
N.Y.

186

NARCISSUS

187

HELIOTROPE
C. M. RICH
Perfumer
N.Y.

188

SUPERIOR

COLOGNE

189

VIOLET PERFUMED

STANDARD AMERICAN

FOR
TOILET
USES

TRADE MARK

DIAMOND
EXTRACT
OF
WITCH-HAZEL

MANUFACTURED BY WM. J. UEBLER, FRANKFORT, N.Y.

190

BUERGER'S
Bonnie
Lassie
Spicy

a New and Delightful
Toilet Essential

THE BUERGER BROS.
SUPPLY CO.
DENVER

191

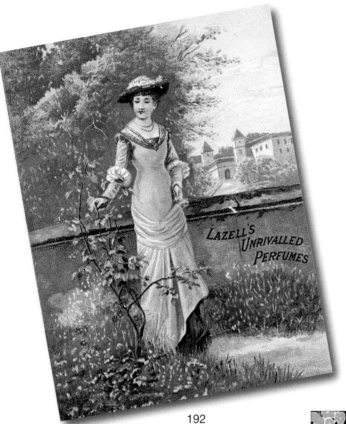

192

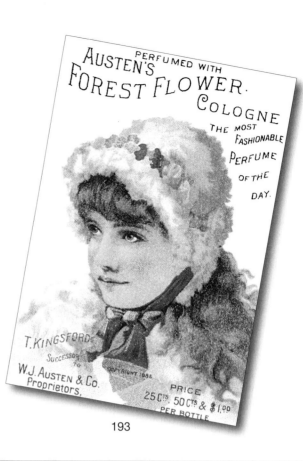

193

194

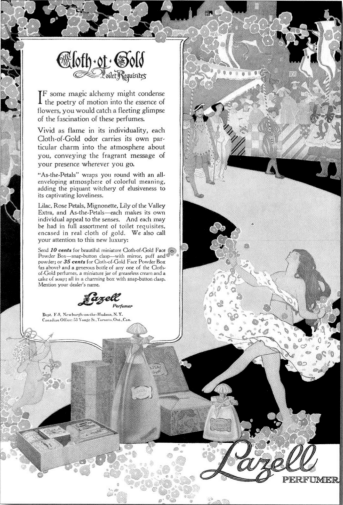

195

47

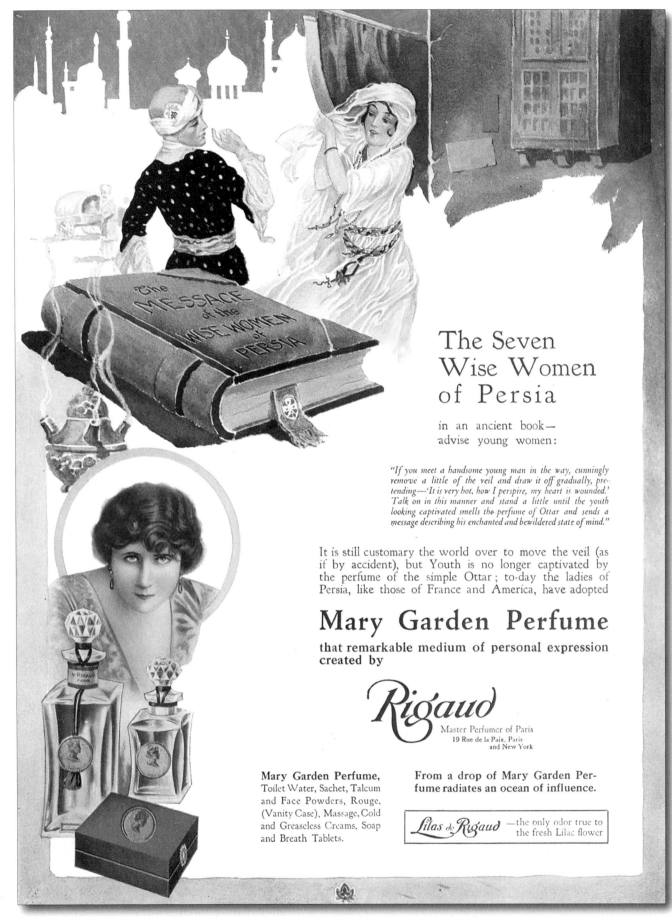

The Seven Wise Women of Persia

in an ancient book —
advise young women:

"If you meet a handsome young man in the way, cunningly remove a little of the veil and draw it off gradually, pretending—'It is very hot, how I perspire, my heart is wounded.' Talk on in this manner and stand a little until the youth looking captivated smells the perfume of Ottar and sends a message describing his enchanted and bewildered state of mind."

It is still customary the world over to move the veil (as if by accident), but Youth is no longer captivated by the perfume of the simple Ottar; to-day the ladies of Persia, like those of France and America, have adopted

Mary Garden Perfume

that remarkable medium of personal expression
created by

Rigaud

Master Perfumer of Paris
19 Rue de la Paix, Paris
and New York

Mary Garden Perfume, Toilet Water, Sachet, Talcum and Face Powders, Rouge, (Vanity Case), Massage, Cold and Greaseless Creams, Soap and Breath Tablets.

From a drop of Mary Garden Perfume radiates an ocean of influence.

Lilas de Rigaud —the only odor true to the fresh Lilac flower